Norman

First published 1986 by GMP Publishers Ltd
 P O Box 247, London NI5 6RW
Text copyright © Nick Stanley 1986
Pictures copyright © the artists 1986
French translation by Elizabeth Ganne
German translation by Christiane Bergob

British Library Cataloguing in Publication Data

 Out in art.
 I. Homosexuality and art 2. Art, modern —
 20th century — English 3. Art, English
 I. Stanley, Nick II. Brown, Christopher
 704'.0664 N678.5.H6

 ISBN 0-907040-77-2
 ISBN 0-85449-027-2 Pbk

Photosetting by Artworkers (Typesetters) Ltd, London NI6
Photography by David Trace, London N7
Colour origination, printing and binding by
 South Sea International Press Ltd., Hong Kong

OUT IN ART

WORKS BY
CHRISTOPHER BROWN
CHRIS CORR
NORMAN
RICHARD ROYLE
GRAHAM WARD
INTRODUCED BY NICK STANLEY

Chris Corr

A Critical Experience

The work brought together here was commissioned from five gay artists all in their twenties. These men have grown up in an age of open gay culture. This however has not led any of them to celebrate it uncritically; they have rather taken the opportunity to examine what the culture means to each of them personally and how they wish to relate to it. The task they have set themselves is an essentially critical one, exploring the possibilities and limitations of the gay life they see around them and of which they are part. There is in all the work a sense of discovery and often a comment on what has been observed.

With the exception of a couple of explicitly propagandist pieces (Chris Corr's last two pictures) the work is indirect in its impact and personal to the artist. Rather than a weakness, this represents a considerable strength. It is through the tentative exploratory quality of the compositions that we come to appreciate the vision and motivating force. We are invited to perceive the world the way it appears to the artist. The overall picture we make extends our view of what gay (and non-gay) life consists of.

One of the most powerful ways of exploring the meaning of gay life employed by these artists is through the analysis of stereotypes, especially those associated with masculinity and sexual imagery. The pornographic image is used by two of the group to provide insights into its role in society. The sixties athletic pin-up from the world of *Physique* magazine provides an ironic contrast with its owner in Graham Ward's *Fantasy Friend*, whilst Richard Royle's *Pornographer* has the tables turned on him: he becomes one of his own fetishised images. In both cases the quiet examination of the image transforms its significance and the effect becomes diffused. The exploitation of the male body is similarly examined by Chris Corr in his *On the Street* where the three hustlers are objects for sale. Yet each of them retains a distinctly different appearance in the same setting: one looks forlorn, another streetwise and tough, whereas the third appears pensive and depressed. This picture underscores the varying ways individuals handle similar situations.

The stereotypes of masculinity so evident in Chris Corr's litany *A Bad Gay Guy* and in Christopher Brown's *Voulez-vous en venir?* are themselves open to subversion. The cliché of the sailor represents not only a homoerotic image but also camaraderie and friendship, romance and poetry. Similarly the toughness of the cowboy celebrated in the Marlborough Man is undermined by Christopher Brown's *St Francis*, who in his plaid shirt is anything but tough, more a sensitive counter-image, like James Dean.

The critique of stereotypes by the artists does not prevent them from celebrating gay heroes. The most prominent of these are literary and include Isherwood, Lorca and Rechy. Literature seems to provide a much stronger source of gay identity than other forms of representation. Genet, Cocteau and Auden provide a gay reference not found visually with the same strength. Of course, visual references are often important, though usually they are not specifically gay. The only direct attempt to 'answer back' art history is Chris Corr's *Birth of Man*, a reply to Botticelli's *Birth of Venus*. Otherwise art-historical references are muted or indirect – Graham Ward's portraits, for example, have references to both Lucien Freud and Gustav Klimt.

If the artists often find narrative structure in literary and visual reference to the world around them, they all draw also on the experience of their own lives. Perhaps the most immediately evident example is Norman's narrative sequence of images charting the breakdown of a relationship. But autobiographical references are clearly to be found in the work of the others. Both Richard Royle and Graham Ward deal with gay childhood and growing up (*Lonely Hearts* and *Little Tango*) while Chris Corr and Christopher Brown each introduce their own experience in *Conscience and Consent* and *Voulez-vous en venir?*

Despite the wide variety in styles, the difference in mood and treatment, the coolness or involvement to be found in the images brought together in this collection, the artists all share a commitment to two interrelated propositions. Firstly, they see as central to gay life a quality that can only be called tenderness. Christopher Brown's *St Francis* is a man of tenderness without aggression, as is the figure in Chris Corr's *Birth of Man*, relaxed and sensuous. The same is true for the young lovers in Graham Ward's *Home Service* who are portrayed as tender but erotic. Richard Royle uses the textural and tactile qualities of gold in his *Lonely Hearts* to offset the hard metallic feel by introducing something he describes as 'specifically feminine'. Perhaps most surprising of all in this category is Norman's *And the Little One Said*. Even in the depths of rejection exemplified in the kiss of his lover for another there yet remains the tender and erotic quality in this kiss that Norman retains and offers us as a vital force.

The need for tenderness is the obverse of the twin proposition that all the artists maintain – one cannot possess another person – one can have objects but never people. All the explorations of stereotypes of gay life underline this common theme. Tenderness and brotherliness go together with emotional freedom. When these are undermined by possessiveness and stereotypic thinking relationships inevitably degenerate. Just how these intertwined themes are developed by each artist is further discussed below. In their variety they are helping define in practical terms what gay art may usefully encompass. By committing themselves to this collection they are engaging in setting out the terms of debates for today.

Nick Stanley

Un essai critique

Les oeuvres rassemblées ici ont été sélectionnées parmi celles de cinq artistes homosexuels tous âgés d'une vingtaine d'années, et qui ont tous grandi à une époque où la culture homosexuelle s'assume au grand jour. Aucun d'entre eux cependant n'a été amené à l'accepter inconditionnellement. Au contraire, ils en auraient plutôt profité pour faire le point sur ce que cette culture signifie pour chacun d'eux et sur la façon dont ils souhaitent s'y référer. La tâche à laquelle ils se sont attelés est donc essentiellement critique, elle explore les possibilités et les limites de la vie homosexuelle dont ils font partie et telle qu'ils la voient autour d'eux. Dans leur ensemble, on constate dans ces oeuvres un sentiment de découverte et souvent une prise de position sur ce qui est observé.

A l'exception de deux travaux explicitement propagandistes (les deux derniers tableaux de Chris Corr), l'impact de ces oeuvres est indirect et personnel à l'artiste. Plutôt qu'une faiblesse, cela représente une force considérable. C'est à travers la qualité d'exploration à l'essai de ces compositions que nous sommes à même d'apprécier la vision et la force qui les motivent. Elles nous invitent à percevoir le monde tel qu'il apparaît à l'artiste. L'impression d'ensemble que nous recevons s'étend à notre impression de ce à quoi correspond la vie homosexuelle (et non-homosexuelle).

L'un des moyens les plus puissants d'explorer la signification de la vie homosexuelle utilisés par les artistes est l'analyse des stéréotypes, en particulier ceux associés à la masculinité et à l'imagerie sexuelle. L'image pornographique est utilisée par deux des membres du groupe pour donner un aperçu de son rôle dans la société. Le modèle athlétique des années 60 découpé dans *Physique magazine* forme un contraste ironique avec son propriétaire dans *Fantasy Friend* de Graham Ward, alors que le *Pornographer* de Richard Royle renverse les rôles: il devient l'un de ses personnages fétichisés. Dans les deux cas, l'examen de ces tableaux transforme leur banalité et diffuse leur effet. L'exploitation du corps humain est examiné de la même façon par Chris Corr dans son *On the Street* où les trois prostitués sont des objets à vendre. Et pourtant, chacun d'eux a son caractère propre dans le même décor: l'un d'eux semble très seul, le second à l'air dur appartient à la rue et le troisième est déprimé et perdu dans ses pensées. Ce tableau illustre les différentes façons dont chaque individu fait face à la même situation.

Les stéréotypes de la masculinité, tellement en évidence dans la litanie *A Bad Gay Guy* de Chris Corr et dans le *Voulez-vous en venir?* de Christopher Brown, sont un appel à la subversion. Le cliché du marin représente non seulement une image homo-érotique mais aussi la camaraderie et l'amitié, le romantisme et la poésie. De même, la rugosité du cowboy idéalisé dans le Marlborough Man est gommée par le *St Francis* de Christopher Brown, dont la chemise écossaise n'a rien de primitif: c'est plutôt un contre-portrait, comme James Dean.

La critique des stéréotypes par les artistes ne les empêchent pas de glorifier les héros homosexuels. Les plus en évidence sont littéraires comme Isherwood, Lorca et Rechy. Il semble que la littérature soit une source d'identification homosexuelle beaucoup plus riche que les autres arts de représentation. Ainsi, Genêt, Cocteau et Auden fournissent des références homosexuelles que l'on ne retrouve pas avec la même intensité dans les arts visuels. Bien entendu, les références visuelles ont souvent leur importance, quoiqu'en général elles ne soient pas spécifiquement homosexuelles. La seule tentative directe de "répartie" à l'histoire de l'art, c'est le *Birth of Man* de Chris Corr, en réponse à la *Naissance de Vénus* de Botticelli. Autrement, les références artistico-historiques sont voilées ou indirectes – les portraits de Graham Ward par exemple font référence à la fois à Lucien Freud et à Gustav Klimt.

Si les artistes trouvent souvent une structure narrative dans les références littéraires et visuelles au monde qui les entoure, ils font tous appel à leurs expériences personnelles. L'exemple le plus évident peut-être, c'est la séquence narrative de Norman détaillant les étapes d'une rupture. Mais on trouve nettement des références autobiographiques dans les oeuvres des autres. Richard Royle comme Graham Ward évoquent l'enfance et l'adolescence homosexuelles (*Lonely Hearts* et *Little Tango*) alors que Chris Corr et Christopher Brown illustrent chacun leur proper expérience dans *Conscience and Consent* et dans *Voulez-vous en venir?*

Malgré la grande diversité de styles, les différences d'humeur et de traitement, la distance ou l'implication qui se dégagent des tableaux rassemblés dans cette collection, les artistes partagent tous le même engagement à deux principes qui sont reliés. D'abord, ils considèrent que le coeur de la vie homosexuelle est une qualité que l'on ne peut qualifier que de tendresse. Le *St Francis* de Christopher Brown est un homme de tendresse, sans agressivité, tout comme le personnage

paisible et sensuel de *Birth of Man* de Chris Corr. On peut en dire autant des jeunes amants dans *Home Service* de Graham Ward, qui sont montrés tendres mais érotiques. Richard Royle se sert des qualités de texture et de tangibilité de l'or de sa suspension pour faire basculer l'aspect de la dureté métallique en y intégrant quelque chose qu'il décrit comme "essentiellement féminin". Mais le plus surprenant de tous dans cette catégorie, c'est peut-être *And the Little One Said* de Norman: même au plus profond de l'abandon illustré dans le baiser de son amant à un autre, il y a encore tendresse et érotisme dans ce baiser que Norman rappelle et nous offre comme une force vitale.

Le besoin de tendresse est l'envers de la double affirmation qu'affichent tous les artistes – on ne peut posséder autrui – on peut posséder les objets mais pas autrui. Toutes les analyses des stéréotypes de la vie homosexuelle soulignent ce thème commun. La tendresse et la fraternité vont de pair avec la liberté des sentiments. Quand elle est minée par la jalousie ou des attitudes stéréotypées, la relation ne peut que se détériorer. La façon dont chacun des artistes a développé ces thèmes jumelés est étudiée ci-après. Leurs différences aident à définir en un peu plus noir sur blanc ce que l'art homosexuel recouvre normalement. En acceptant de faire partie de cette collection, ils délimitent les termes du débat d'aujourd'hui.

Nick Stanley

Eine kritische Erfahrung

Die Arbeiten, die hier zusammengetragen wurden, kommen von fünf schwulen Künstlern, die alle in den Zwanzigern sind. Das Alter ist insofern wichtig, als daß diese Männer in einer Zeit geboren sind, die der homosexuellen Szene offener entgegensteht. Das hat allerdings bei keinem zu einer unkritischen Einstellung geführt, sondern ließ eher der Möglichkeit Raum, zu erforschen, was dieses Feld für jeden von ihnen persönlich bedeutet und wie sie dem gegenüber stehen. Die Aufgabe, die sie sich stellten ist besonders schwierig: es ging darum die Möglichkeiten und Limitierungen der Homosexuellen anhand ihrer eigenen Umgebung zu entdecken, also in der Szene, in der sie selbst zu Hause sind. Alle Arbeiten zeigen gewisse Erfahrungen, häufig bringen diese Beobachtungen persönliche Stellungnahmen mit sich.

Außer Zwei offensichtlich propagandistischen Werken (die letzten zwei Bilder der Serie von Chris Corr), sind die gezeigten Arbeiten in ihrer Wirkung eher indirekt und beziehen sich auf das persönliche Leben des Künstlers. Das zeugt eher von selbstbewußter Stärke als von Schwäche. Gerade die suchende, forschende Qualität der Kompositionen, läßt den Betrachter Sichtweise und Motivation erkennen. Der Künstler lädt den Betrachter ein, die Welt mit seinen Augen zu sehen. Das daraus entstehende Gesamtbild erweitert unser Verständnis von homosexuellem (und nicht-homosexuellem) Dasein und dessen Inhalt.

Eine der wirksamsten Möglichkeiten zur Erforschung der Schwulenszene und dessen Bedeutung, ist für diese Künstler die Studie stereotyper Beispiele, besonders die, die gewöhnlich mit Männlichkeit und Sexualsymbolen verbunden werden. Zwei Künstler der Gruppe benutzen dazu pornographische Darstellungen um einen Einblick in diese Gesellschaftsrollen zu geben. Der athletische Pin-up im Stil der 60er Jahre aus der

Sicht des *Physique Magazine,* provoziert einen ironischen Kontrast zu seinem Leser in Graham Wards *Fantasy Friend,* während Richard Royles *Pornographer* die Aufmerksamkeit auf sich selbst lenkt: er wurde zum Fetisch seiner eigenen Themen. In beiden Fällen verändert die schlichte Art, mit der das Motiv behandelt wurde, seine Bedeutung und mildert die Wirkung. Die Ausbeutung des männlichen Körpers wird auf eine ähnliche Weise von Chris Corr in seinem *On the Street* erforscht, wo es um drei käufliche Strichjungen geht. Jeder von ihnen bewahrt jedoch eine sich klar von einander unterscheidende Erscheinung in gleicher Umgebung: der Eine schaut verloren, der Andere sieht eher rauh und straßenjungenhaft aus, während der Dritte nachdenklich und betrübt erscheint. Dieses Bild unterstreicht die verscheidenen Weisen, mit denen der Einzelne ähnliche Situationen behandelt.

Die sichtbar maskulinen Stereotypen in Chris Corrs Litanei *A Bad Gay Guy* und in Christopher Browns *Voulez-vous en Venir* sind schon in sich subversiv. Das Klichee des Seemanns verkörpert nicht nur ein homoerotisches Image sondern auch Kameraderie und Freundschaft, Romantik und Poesie. So wird auch die rauhe Art eines Cowboys, die mit *Marlborough Man* hervorgehoben wird, von Christopher Brown in *St Francis* unterminiert – hier sieht er mit seinem karierten Hemd alles andere als rauh aus – hier wird mit dem feinfühligen, James Dean-artigen Look eher das Gegenteil verkörpert.

Die Kritik des Künstlers an diesen stereotypen Erscheinungs formen hält ihn allerdings nicht davon ab die Stars der Schwulenszene zu zelebrieren. Die Prominentesten darunter sind in der Literatur zu finden, so z.B. Isherwood, Lorca und Rechy. Die Schwulenwelt scheint einen viel stärkeren Hang zur Identifizierung mit literarischen Quellen zu haben, als zu anderen Darstellungsformen. Die Bezüge und Verweise auf Genet, Cocteau und Auden sind bei Schwulen weit häufiger zu finden, als Quellen im visuellen Bereich. Optische Einflüsse sind natürlich oft sehr wichtig, es handelt sich dabei aber weniger um erwiesermaßen homosexuelle Referenzen. Der einzig direkte Versuch einer "Erwiederung" auf die Kunstgeschichte ist Chris Corrs *Birth of Man,* eine Antwort auf Botticellis *Geburt der Venus.* Im Übrigen sind kunsthistorische Verweise indirekt und versteckt – Graham Wards Porträts haben z.B. Anspielungen auf Lucien Freud und Gustav Klimt.

Benutzen die Künstler auch häufig Erzählungen aus der Literatur und visuelle Bezüge aus ihrer Umwelt, so malen sie auch die Erfahrungen, die sie am eigenen Leib erfahren haben. Das vielleicht sichtbarste Beispiel sind die Bilder von Norman, deren erzählender Charakter das Ende einer Beziehung zeigt. Autobiographische Züge sind auch in den Werken der anderen klar zu erkennen. Richard Royle und Graham Ward beschäftigen sich beide mit der Kindheit und Jugend Homosexueller (*Lonely Hearts* und *Little Tango*); Chris Corr und Christopher Brown befassen sich mit ihren eigenen Erfahrungen in *Conscience and Consent* und *Voulez-vous en venir?.*

Gibt es auch große Unterschiede in Stil, in Stimmung und Betrachtungsweise, in der Distanziertheit oder Einbeziehung, die man in dieser Sammlung finden kann, so teilen doch alle Künstler die Bindung an zwei, in Wechselbeziehung stehender Dinge. Zum Ersten sehen sie eine Qualität des homophilen Lebens als essentiell an – eine Qualität, die man nur Zärtlichkeit nennen kann. Christopher Browns *St Francis* zeigt einen Mann voller Zärtlichkeit und ohne jede Aggression, so auch die Gestalt in Chris Corrs *Birth of Man,* die entspannt und sinnlich ist. Das Gleiche gilt für die jungen Liebhaber in Graham Wards *Home Service,* die so zärtlich wie erotisch porträtiert sind. Richard Royle benutzt die textlichen und taktilen Eigenschaften von Gold in seiner Arbeit um das harte metallische Gefühl mit etwas, daß er als "speziell weiblich" bezeichnet, auszugleichen. Vielleicht ist *And the Little One Said* von Norman in dieser Beziehung am erstaunlichsten. Selbst im Kummer der Ablehnung, die sich in dem Kuß seines Liebhabers mit einem Anderen widerspiegelt, bewahrt er noch etwas Zärtliches und Erotisches in diesem Kuß, den Norman uns als eine lebenswichtige Kraft anbietet und festhält.

Das Bedürfnis nach Zärtlichkeit bleibt bei allen Künstlern sichtbar – man kann eine andere Person nicht besitzen, man kann Dinge besitzen, aber keine Menschen. All die Erforschungen stereotyper Formen des Schwulenlebens, unterstreichen dieses gemeinsame Thema. Zärtlichkeit und Brüderlichkeit laufen parallel mit emotionaler Freiheit. Wenn diese Dinge durch Besitzansprüche und stereotypes Denken unterminiert werden, degenerieren Freundschaften unweigerlich. Inwiefern diese, mit einander verflochtenen Themen, in den Augen jeder dieser Künstler sichtbar werden, wird nachstehend weiter beleuchtet. In ihrer Vielfalt helfen sie mit geübten Mitteln zu einer hilfreichen Definition der homophilen Kunst und deren Inhalte. Mit dieser Sammlung stellen die hier vertretenen Künstler ihre Zugehörigkeit bloß und setzen damit den Grundstein zur heutigen Diskussion dieses umstrittenen Themas.

Nick Stanley

Graham Ward

Christopher Brown

Les tableaux de Christopher Brown ont une certaine distance et une certaine froideur. Il décrit *Il vaut son pesant d'or (Minuit)* comme un "évènement imaginaire de la vie réelle". Cette description s'applique bien à la plupart de son oeuvre. Il admet qu'à l'occasion, ses tableaux semblent froids et analytiques, et conçus sans rien laisser au hasard. Mais il ne cherche pas à obtenir un tableau rempli de détails réalistes. Pour lui, le sens symbolique est beaucoup plus important. On peut en juger par l'importance qu'il attache à ses sources littéraires. Pour lui, chaque observation des personnages est un petit poème. A l'occasion, il l'accompagne même de vers. A partir des mots dans sa tête s'élabore une phrase accompagnée d'une image, comme par exemple dans son tableau *Lorca, the Gay Imagination*. Ce tableau déborde d'images puisées dans les poèmes de Lorca et retransmises visuellement. Ainsi la marionnette dans la main du poète ne fait pas seulement référence à son intérêt pour les marionnettes mais aussi à son célèbre poème du toréador.

L'image symbolique la plus présente dans cette série, c'est l'oiseau. Les implications du motif sont analysées graphiquement dans *Extraordinary Bird*. Le point de départ en est un conte de fées dont se souvient le peintre et qui retrace la quête d'un oiseau extraordinaire (rose dans le tableau) par un jeune garçon, la capture de l'oiseau et la réalisation de sa tristesse quand il demeure enfermé dans une cage et qu'on le surveille sans arrêt. Bien entendu, l'oiseau, c'est un garçon. Le thème est repris dans *Two Exotic Birds*, où le conflit devient érotique et sexuel. Les garçons sont enlacés dans la même étrainte. Le garçon au T-shirt est l'oiseau, l'oiseau révélé – avec des traits beaucoup, plus élaborés, exotique dans un décor exotique.

Christopher Brown explore des thèmes homosexuels déjà reconnus d'une manière générale mais aucun d'entre eux n'est un simple stéréotype – ils se distancent tous du spectateur, dans le temps et dans l'espace. Les marins, le garçon dans le bar, ou St François sont une distillation, symbolique mais froidement théâtrale. Et peut-être un commentaire de la façon dont nous nous conduisons les uns envers les autres.

Christopher Browns Bilder haben eine kühle, objektive Distanz. Er beschreibt *Il vaut son pesant d'or (Minuit)* als ein "erdachtes Ereignis aus dem wahren Leben". Diese Beschreibung trifft auf die meisten seiner Arbeiten zu. Er gesteht zu, daß seine Arbeiten gelegentlich kalt und analytisch erscheinen mögen, aber es ist auch nicht sein Anliegen Bilder zu produzieren, die voller realistischer Details sind. Ihm ist die symbolische Bedeutung viel wichtiger. Das zeigt sich auch in der Wichtigkeit, die er den Quellen beimißt. Er beschreibt seine Beobachtungen von Menschen als kleine poetische Werke. Manchmal komponiert er dazu auch Worte. Aus den Worten entwickelt sich ein Satz im Kopf und mit ihm eine bildliche Vorstellung. Das Werk *Lorca, the Gay Imagination* zeugt von dieser Arbeitsweise. Das Bild zeigt eine Fülle von Darstellungen, die nach den Gedichten Lorcas gezeichnet und visuell überarbeitet wurden. So spielt z.B. die Marionette in der Hand des Poeten nicht nur auf dessen Beziehung zum Marionettenhaften an, sondern auch auf dessen berühmtes Gedicht über einen Stierkämpfer.

Das beste Einzelsymbol in dieser Serie ist die Darstellung des Vogels. Der Sinngehalt dieses Motivs wird in *Extraordinary Bird* sichtbar. Den Anstoß gab ein Märchen, daß dem Maler in Erinnerung blieb. Es beschreibt die Suche eines Jungen nach einem außergewöhnlichen Vogel (rosa im Bild), dessen Gefangennahme und die Entdeckung vom Unglück des Vogels, der in einem Käfig der Freiheit beraubt ist und jeder Zeit beobachtet werden kann. Der Vogel ist – selbstredend – ein Junge. Das Thema wurde in *Two Exotic Birds* wieder aufgegriffen, wo der Konflikt erotisch und sexuell wird. Die Jungen sind in einer Umarmung oder Umklammerung festgehalten. Der Junge im T-Shirt ist zum Besitz des anderen im roten Hemd geworden. Der Junge im T-Shirt ist der Vogel, der offenbarte Vogel – mit viel feineren Zügen – ein Exot in exotischer Umgebung.

Christopher Brown beschäftigt sich außerdem mit allgemein bekannten homosexuellen Motiven, aber keine davon sind einfach stereotyp, sondern distanzieren sich vom Betrachter in sowohl Zeit als auch Raum. Die Seemänner, der Junge in der Bar, St Francis – all das sind symbolische Destillierungen, aber kühl theatralisch. Vielleicht eine Kritik an der Art, wie wir miteinander umgehen.

12

Christopher Brown

Christopher Brown's pictures have a cool, detached distance. He describes *Il Vaut son pesant d'or (Minuit)* as an 'imaginary incident from real life'. This description fits most of his work well. He concedes that his work may on occasion seem cool and analytic, designed without leaving anything to chance. But he does not set out to produce a painting full of realist detail. For him, symbolic meaning is far more important. This can be judged from the importance he attaches to literary sources. He describes his observation of people as little poetry pieces. He actually composes in words on occasions. From the words in the mind a sentence develops and alongside it an image. The picture *Lorca, the Gay Imagination* works in this particular way. The picture is replete with images drawn from Lorca's poetry and reworked visually. For example, the puppet in the poet's hand refers not only to his involvement with puppetry but also to his famous poem about a bullfighter.

The most prominent single symbolic image in this series is the bird. The implications of the motif can be explored graphically in *Extraordinary Bird*. The impetus for the piece was a fairy story still in the painter's mind which plots the search by a boy for an extraordinary bird (pink in the picture), the capture of the bird, and the discovery of the unhappiness of the bird at remaining trapped in a cage where he is observed all the time. The bird is, of course, a boy. The theme is taken up again in *Two Exotic Birds* where the conflict becomes erotic and sexual. The boys are held together in a hug or embrace. The boy in the T-shirt has become the possession of the one in the red shirt. The boy in the T-shirt is the bird, the revealed bird – much finer featured, an exotic in an exotic setting.

Christopher Brown also explores more generally recognised gay images, but none of these are simple stereotypes – they all have a distance, both in time and space, from the viewer. The sailors, the boy in the bar, St Francis, are distillations, symbolic but coolly theatrical. Perhaps a comment on how we conduct our dealings with each other.

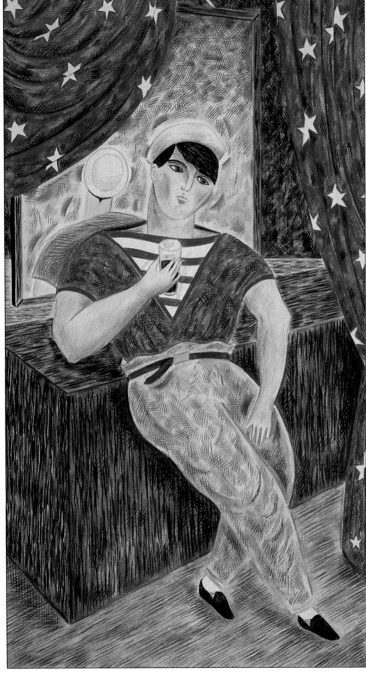

Boy in Bar 1983

36 x 46 cms

Colour pencil

**Voulez-vous
en venir?**

1983

40 × 46 cms

Colour print

15

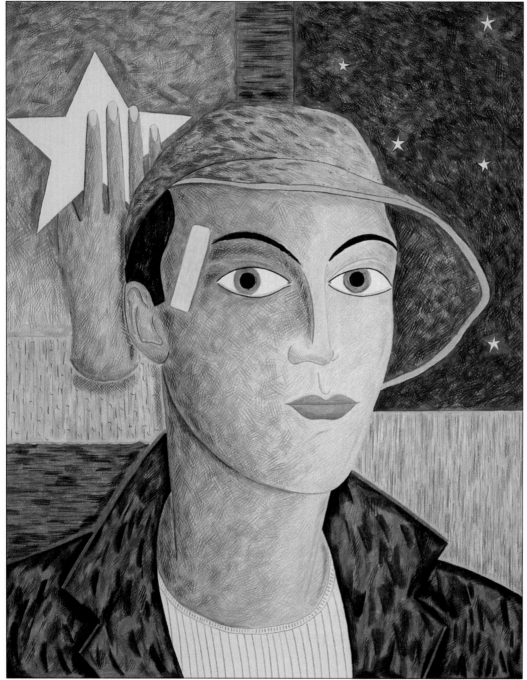

Il vaut son pesant d'or (Minuit)
1983

36 x 42 cms

Colour pencil

**Il vaut son
pesant d'or
(Daytime)**
1983

36 x 42 cms

Colour pencil

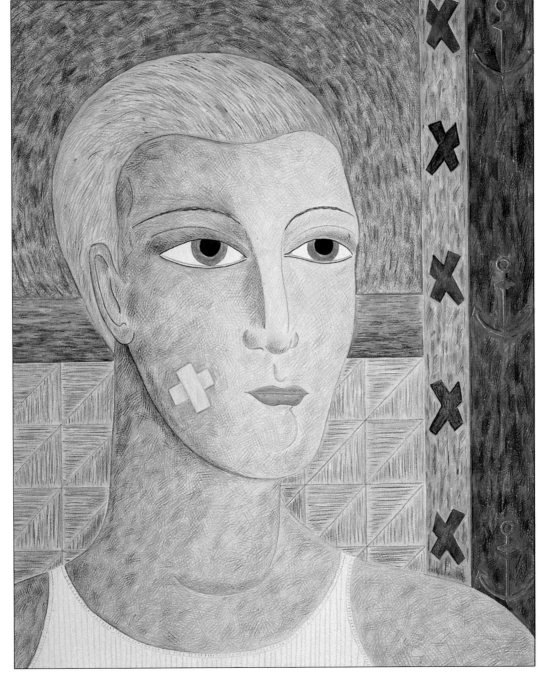

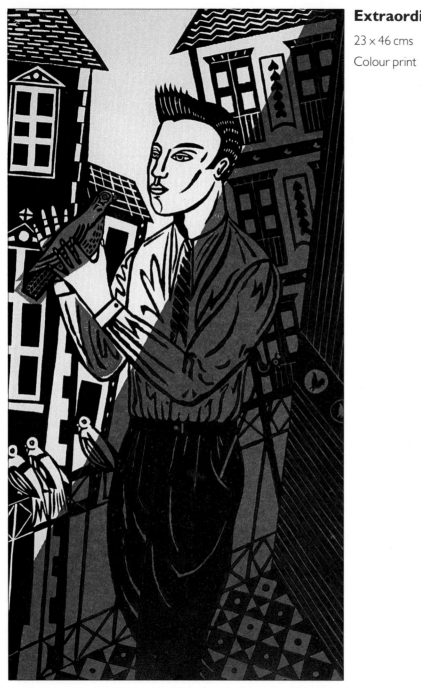

Extraordinary Bird 1984

23 x 46 cms

Colour print

18

Lorca, the Gay Imagination

1984

36 x 42 cms

Colour pencil

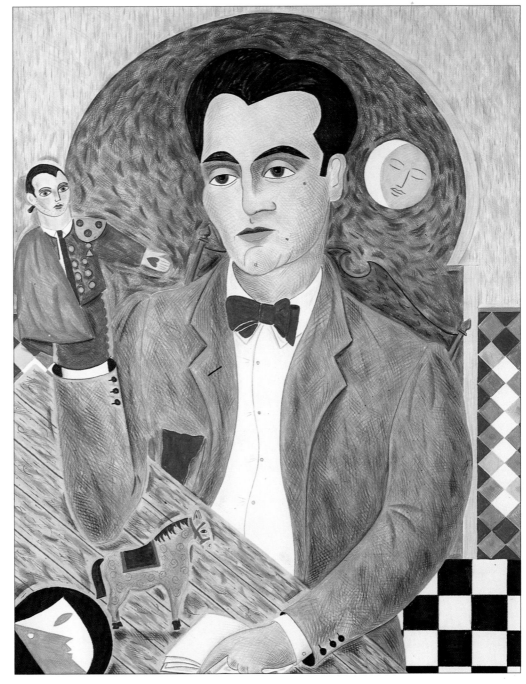

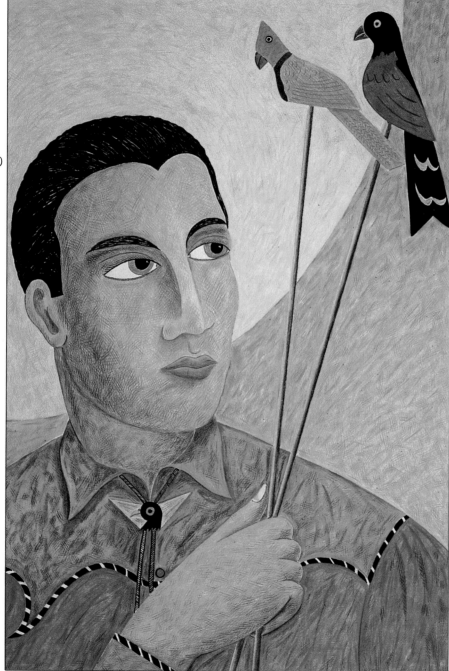

St Francis 1984

37 × 53 cms

Colour pencil

Two Exotic Birds

1985

29 x 46 cms

Colour pencil

En total contraste avec Christopher Brown, les tableaux de Chris Corr font un commentaire ouvert de ce qu'ils portraitisent. Plutôt que d'enregistrer l'apparence des évènements, Chris Corr essaie de pénétrer les gens qu'il dessine. Il est inévitable qu'il nous offre ses propres valeurs. Ses tableaux, quoique beaucoup plus expressionistes que photographiques, n'en demeurent pas moins didactiques et se vouent à commenter les aspects de la vie homosexuelle. Même ceux d'origine surtout littéraire comme *Conscience and Consent* se transforment en une réflexion et un commentaire personnels.

Ce tableau s'inspire de l'étude d'un livre de John Rechy alors que Chris était encore à l'université. La thèse sous-jacente en est la difficulté et la douleur souvent associées à la prise de conscience de l'homosexualité. L'un de ces aspects est illustré dans ce tableau – la culpabilité ressentie par les jeunes gens après une expérience sexuelle. Chris Corr a présenté ce tableau dans son dossier de fin d'études à titre de prise de position personnelle.

Les tableaux de Chris Corr s'intéressent aux aspects positifs et négatifs de la vie homosexuelle. La série *Men of the World*, une rapide succession d'ébauches voilées de têtes d'hommes, s'attache à montrer un kaléidoscope de différents types de caractéristiques associées à des individus du monde entier, et agit comme une célébration de la beauté de tous les hommes. Une observation personnelle en Amérique du Nord et en Sicile contribue également à la variéte des silhouettes toutes issues de travaux antérieurs sur place, dessins ou photos. *On the Street* – évoqué plus haut – représente cette compression des évènements et d'images, bien que le commentaire soit triste. Chris Corr a découvert que la prostitution sur la 42nd Street à New York était déprimante et engendrait un style de vie dur, solitaire et avilissant. Par contre, les voyages lui ont apporté des images chaleureuses et positives. Taormina, où le fantôme de Wilhelm von Gloeden hante encore les reproductions de ses portraits de jeunes Siciliens, sert de référence à la fois pour les deux jeunes hommes de *Sicily* et pour le tableau voisin *Sicilian Portraits*.

Inévitablement, les deux tableaux de propagande ironique *An Ideal Gay Boy* et *A Bad Gay Guy* illustrent très clairement ce que ressent Chris Corr devant les côtés enrichissants et dégradants de la vie homosexuelle. Le contraste est instructif. Le rendu dans le premier groupe d'images est simple et audacieux, en rouge et en noir, quoique le fond blanc du papier ressorte en dessous pour alléger le tableau. Le message est simple: santé, loyauté et solidarité s'appuyant sur la prise de conscience politique sont les qualités requises indispensables à une vie homosexuelle réussie. Par contraste, le climat de *A Bad Gay Guy* est sombre et névrosé, symbolisé par le fond jaune. Cette imagerie illustre l'argument de Chris Corr que certains homosexuels ne vivent que pour la découverte de nouvelles jouissances sexuelles, usant leur corps par l'abus des drogues et des nourritures frelatées, et ne pouvant trouver de plaisir dans une vie réglée qu'ils jugent aseptisée et anémique.

Chris Corrs Bilder geben, ganz im Gegensatz zu Christopher Brown, einen offensichtlichen Kommentar zu dem, was sie darstellen. Anstatt das Geschehen schlicht aufzuzeichnen, versucht Chris Corr in die Dargestellten Personen zu dringen. Das zeigt uns natürlich seine eigenen Wertvorstellungen. Obwohl seine Bilder viel eher expressionistisch als photographisch sind, bleiben sie doch didaktisch und der Aufzeichnung verschiedener Aspekte des homosexuellen Lebens treu. Selbst solche Arbeiten wie *Conscience and Consent*, das den literarischen Ursprung aufweist, entwickelt sich zu persönlichen Stellungnahmen. Dieses Bild ist das Ergebnis einer intensiven Beschäftigung mit den Büchern von John Rechy, während Chris noch studierte. Die unterschwellige These beschreibt die schmerzvollen Erfahrungen und Schwierigkeiten, die mit der Entdeckung von homosexuellen Neigungen verbunden ist. Einer dieser Punkte wird in diesem Bild behandelt – das Schuldgefühl junger Männer in Bezug auf ihre sexuellen Erfahrungen. Chris Corr stellte dieses Bild in seiner Abschlußprüfung als ein persönliches Statement aus.

Chris Corrs Bilder beschäftigen sich mit positiven sowie negativen Aspekten des homophilen Alltags. Die *Men of the World* Serie – eine rasche Abfolge verschwommener Inpressionen von Männerköpfen – versucht ein Kaleidoskop verschiedener Gesichtszüge aus aller Welt darzustellen und fungiert als eine Zelebrierung der Schönheit aller Männer. Eigene Beobachtungen in Nordamerika und Sizilien tragen zu der mannigfaltigen Darstellung der Figuren bei und basieren auf früheren Zeichnungen und Photos am Ort. Die bereits erwähnte Arbeit *On the Street* verkörpert diese Ansammlung von Geschehen und Vorstellungen, obwohl es sich hier um eine freudlose Aussage handelt. Chris Corr fand die treibenden Massen in New Yorks 42nd Street depremierend und voll harter, einsamer und häßlicher Leben. Reisen gab ihm aber auch freundliche, warme und positive Eindrücke.

Taormina, wo der Geist Wilhelm von Gloedens noch durch die Reproduktionen seiner Porträts von sizilianischen Jugendlichen fortlebt, gab das Thema für die beiden jungen Männer in *Sicily* als auch für das dazugehörige Werk der gleichen Zeit *Sicilian Portraits*.

Die zwei ironischen Propagandaarbeiten *An Ideal Gay Boy* und *A Bad Gay Guy* sind unweigerlich die klarsten Beispiele von Chris Corrs Sicht der wertvollen und verderblichen Seiten homosexueller Lebensformen. Der Kontrast ist lehrreich. Die Behandlung der ersten Themengruppe ist einfach und deutlich in rot und schwarz, obwohl der durchscheinende weiße Untergrund des Papiers dem Bild die Leichtigkeit bewahrt. Die Botschaft ist einfach: Gesundheit, Loyalität und Solidarität auf politischem Bewußtsein basierend, sind die Voraussetzung für einen guten Lebensstil als Schwuler. Im Gegensatz dazu ist die Stimmung in *A Bad Gay Guy* betrübt und neurotisch, was durch die gelbe Tönung symbolisiert wird. Dieses Image veranschaulicht Chris Corrs Behauptung, daß einige Homosexuelle auf permanenter Suche nach neuen sexuellen Reizen sind und ihre Körper durch Drogen und schlechte Ernährung mißbrauchen. Das Problem mit diesem, an Dante erinnernden Katalog der Geretteten und Verdammten, liegt darin, daß das liederliche Leben aufregender erscheint und das normale Leben steril und blutarm.

Chris Corr

In marked contrast to Christopher Brown, Chris Corr's pictures comment openly on what they portray. Rather than registering the appearance of events Chris Corr tries to get into the people he draws. Inevitably he also offers us his own values. His pictures, though far more expressionist than photographic, nevertheless remain didactic and devoted to commenting on aspects of gay life. Even those with the most literary of origins like *Conscience and Consent* develop into personal comments and reflection. This picture came out of an intense study of John Rechy's books while Chris was still at college. The underlying thesis is the difficulty and pain often associated in coming out as gay. One feature of this is treated in the picture – the guilt felt by young men over sexual experience. Chris Corr included this picture in his final degree show as a personal statement.

Chris Corr's paintings deal with both positive and negative aspects of gay life. The *Men of the World* series, a rapid succession of misty impressions of men's heads, sets out to provide a kaleidoscope of different types of features associated with individuals from around the world and acts as a celebration of the beauty of all men. Personal observation in North America and Sicily also contributes to the variety of figures all derived from earlier work on location as drawings or photographs. *On the Street* mentioned earlier represents such a compression of events and images, though here the comment is one of sadness. Chris Corr found the hustling on New York's 42nd Street depressing and productive of tough, lonely and ugly lifestyles. But travel also provided him with warm and positive images. Taormina, where the ghost of Wilhelm von Gloeden still hovers in the reproductions of his portraits of Sicilian youths, provides a reference for both the two young men in *Sicily* and the companion piece *Sicilian Portraits*.

Inevitably, the two ironic pieces of propaganda *An Ideal Gay Boy* and *A Bad Gay Guy* are the clearest expression of Chris Corr's feelings about what he sees as the valuable and the pernicious sides of gay life. The contrast is instructive. The treatment in the first group of images is simple and bold in red and black, though with a lot of the white of the paper showing through to keep the picture light. The message is simple: health, loyalty and solidarity based on political awareness, are the prerequisite qualities for a good gay life. By contrast, the mood of *A Bad Gay Guy* is dark and neurotic, symbolised by the overlay in yellow. The imagery illustrates Chris Corr's argument that some gay men rove in constant search of new sexual excitement, abusing their bodies through drugs and junk food.

The problem with this Dante-like catalogue of the saved and damned is that the bad life looks exciting and the good life aseptic and anaemic.

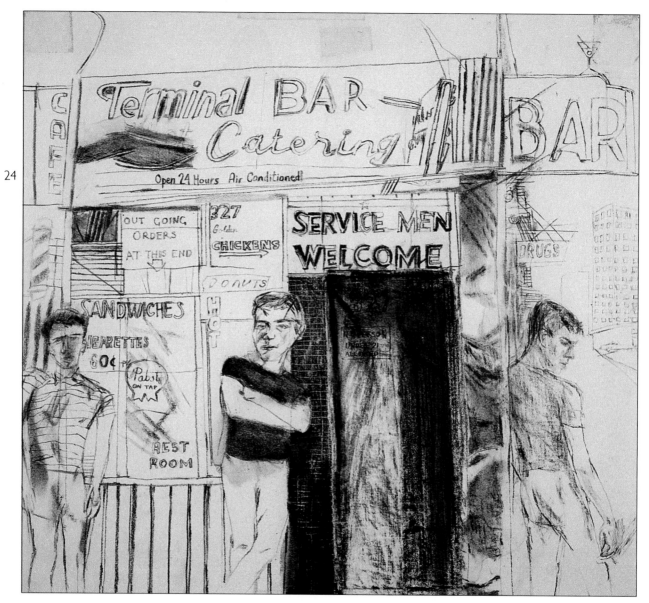

On the Street 1980

31 × 28 cms

Pencil drawing

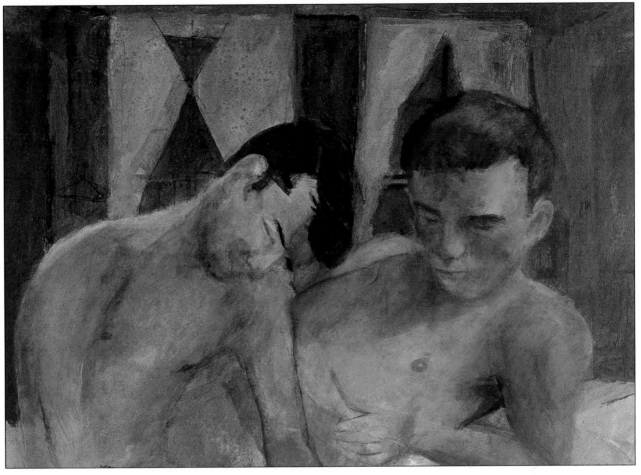

Conscience and Consent 1980

23 x 32 cms

Acrylic

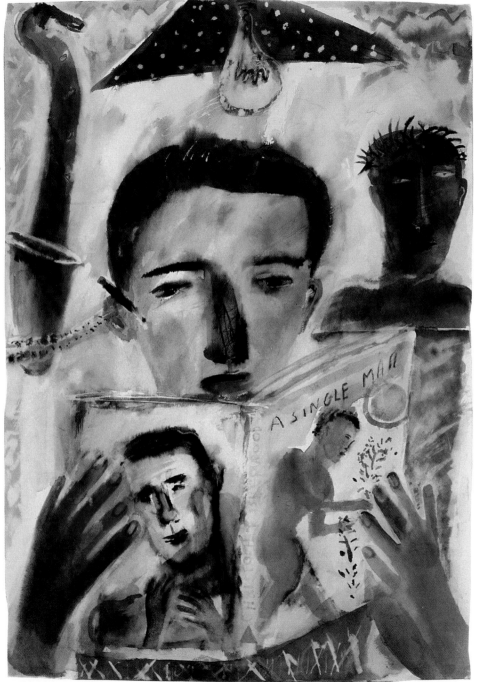

A Single Man 1984

36 x 51 cms

Red and black wash

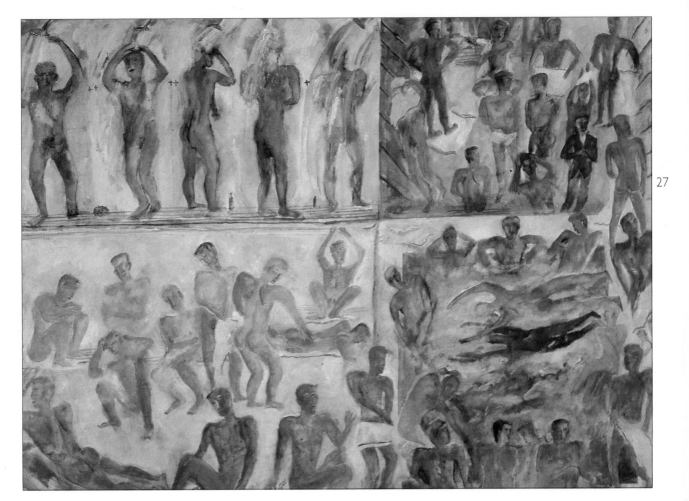

Public Steambaths 1984

86 × 122 cms

Powder, gouache

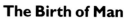

The Birth of Man 1984

36 × 50 cms

Powder, gouache

28

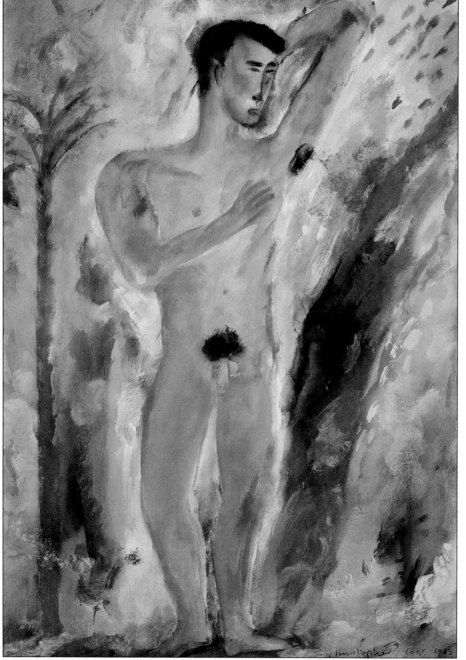

Sicily 1984

64 x 107 cms

Powder, gouache

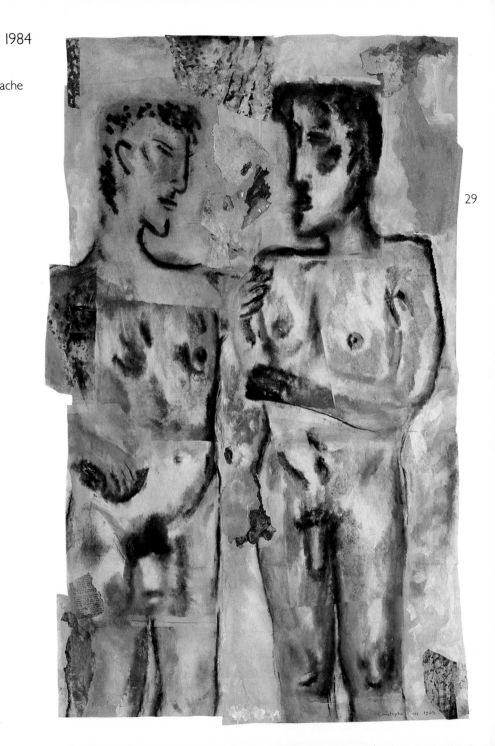

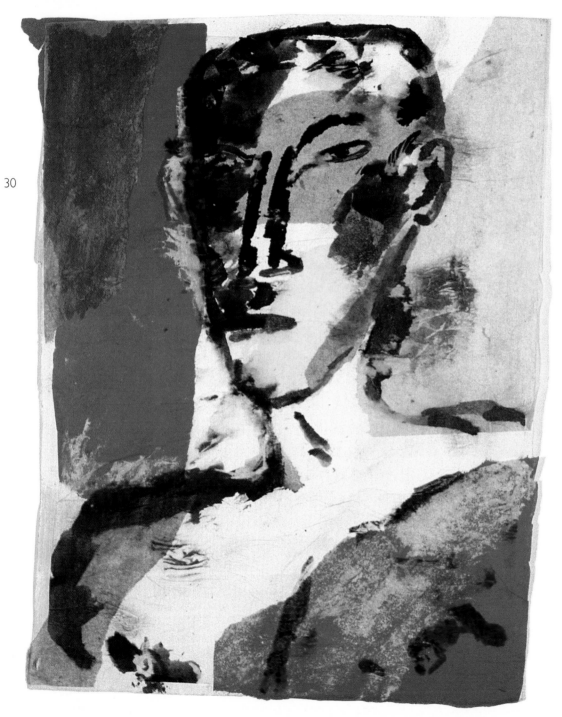

Sicilian Portraits
(diptych) 1984

each panel 20 × 28 cms

Collage and watercolou

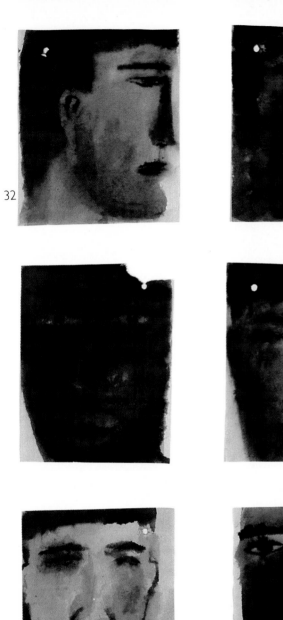

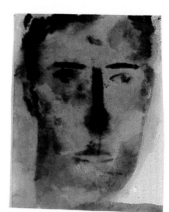

Men of the World I
1984
45 x 53 cms
Ink wash

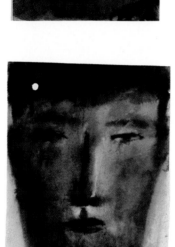
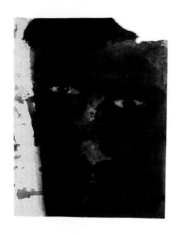
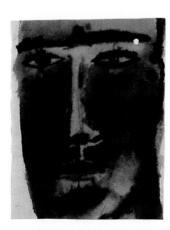

Men of the
World 2

84

5 × 53 cms

k wash

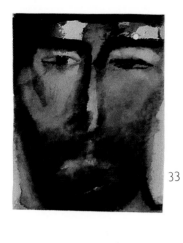

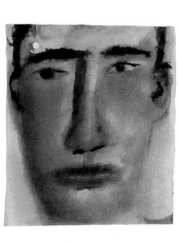

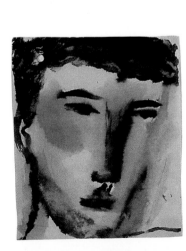
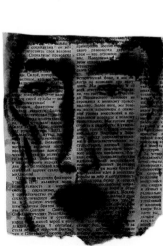

AN IDEAL GAY BOY

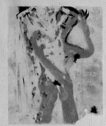 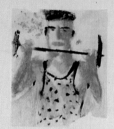 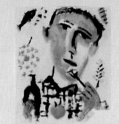

STAYS CLEAN KEEPS FIT EATS SENSIBLY

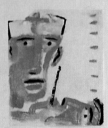 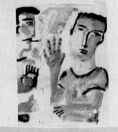 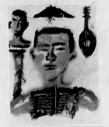

KEEPS HEALTHY NEVER SMOKES IS STUDIOUS

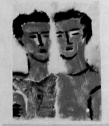

A LOYAL AND GOOD FRIEND FIGHTS FOR HIS RIGHTS GOES EARLY TO BED

An Ideal Gay Boy 1985

45 x 53 cms

Gouache

A Bad Gay Guy 1985

61 × 87 cms

Gouache

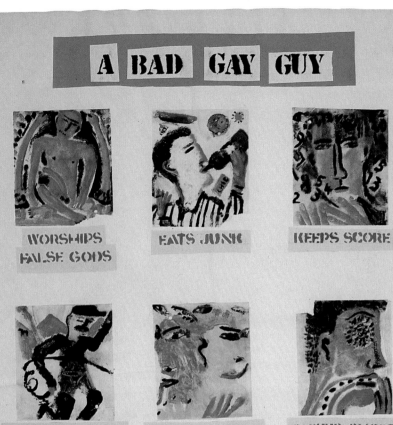

Au premier coup d'oeil, la séquence de tableaux de Norman a l'air d'un morceau d'autobiographie pur et sincère, présenté tel qu'il s'est passé. En réalité, cette série représente une construction réfléchie dans laquelle la signification des événements prend le pas sur la séquence. Le sens de chaque étape n'est compris qu'après l'évènement. La première image, par exemple, agit à la fois comme introduction et récapitulation à la série toute entière. Assis devant son miroir pour s'épiler les sourcils avant de sortir pour la soirée, il confronte sa propre image – sa personnalité. Ce qui le met face à face avec les plus classiques des questions: Qui est-il? Que fait-il? Cela lui donne des doutes sur tout, et en particulier il se demande si la liaison avec son amant va durer. Le reste de la série se voue à répondre à ces questions.

La séquence narrative contient une logique interne et retrace la détérioration de la liaison de Norman avec son amant. Les tableaux illustrent les thèmes de la vie homosexuelle presque comme une illustration perverse ou la répartie aux morceaux de propagande de Chris Corr. Si *The Mirror* exemplifie l'insécurité personnelle, *Lisa Likes a Drink* transporte la scène dans un nightclub où Norman et son amant éprouvent l'un pour l'autre le même ennui que pour le cadre qui les entoure. Cet ennui se transforme ensuite en une violente dispute et en hostilité dans *The Broken Door*. C'est le

début de la rupture, où l'amant de Norman commence à s'intéresser à un nouveau partenaire sexuel comme dans *And the Little One Said*. Le dernier tableau montrant la rupture, *Die, Monster, Die*, illustre à la fois le chagrin de l'abandon et les raisons qui entraîneront la guérison. La tête rasée représente la réponse de Norman à l'abandon et à la dépression. En se rasant la tête et les sourcils, il affiche son sentiment personnel de laideur – "Si je me sens laid, autant avoir l'air laid." Mais le tableau illustre également la thèse principale de Norman: c'est qu'à travers le dessin et la peinture, on peut accepter sous une forme non-verbale certains des aspects les plus déroutants et les plus perplexes de la vie – qu'ils soient douloureux ou heureux. Mettre sur le papier *And the Little One Said* la nuit où son amant l'a quitté a donné à Norman les moyens de faire face à cette issue. La version dans cette collection a été réalisée deux mois plus tard, et s'avère plus distante et plus tolérante au changement qui s'est passé.

L'oeuvre de Norman n'est pas construite en fonction de la vie homosexuelle et elle n'est pas non plus destinée uniquement á un public homosexuel. Elle représente *son* existence. Le fait qu'il soit homosexuel demeure inévitablement un élément central de son oeuvre; on y retrouve de façon particulièrement nette la rémission honnête d'une épreuve douloureuse.

Normans Arbeiten sehen auf den ersten Blick so aus wie ein Stück klarer, offener Autobiographie, genauso zu Papier gebracht wie es tatsächlich passierte. In Wirklichkeit liegt dieser Serie ein bewußter Aufbau zu Grunde, indem die Bedeutung des Geschehens mehr Priorität als die Szene selbst hat. Der tiefere Sinn der einzelnen Abschnitte kann nur im Rückblick verstanden werden. So fungierte das erste Bild z.B. als Einführung sowohl als Übersicht der ganzen Serie. Er konfrontiert sich darin mit seinem eigenen Ebenbild – seiner Persönlichkeit, indem er vor einem Spiegel sitzt und seine Augenbrauen zupft bevor er ins Nachtleben geht. Das stellt ihn vor die grundlegende Frage: Wer ist er? Was macht er? Es bringt in ihm generelle Zweifel auf, läßt ihn den Halt der Beziehung zu seinem Liebhaber in Frage stellen. Die übrigen Arbeiten dieser Serie beschäftigen sich mit den Antworten zu diesen Problemen.

Der erzählende Charakter der Szenen beinhaltet eine innere Logik und zeichnet ein Bild von der langsamen Verschlechterung der Beziehung zwischen Norman und dessen Liebhaber. Die Illustrationen stellen Themen aus der Schwulenszene schon fast pervers dar und sind mit Chris Corrs Propagandastücken zu vergleichen. Veranschaulicht *The Mirror* persönliche Unsicherheit, so verlegt sich das Geschehen in *Lisa Likes a Drink* nach einem Nachtclub, wo Norman und sein Partner mit sich und ihrer Umgebung gelangweilt sind. Langeweile dagegen verwandelt sich zu heftiger Auseinandersetzung und Feindseligkeit in *The Broken Door*. All das ebnet den Weg für das Ende der Beziehung, das langsam wachsende sexuelle Interesse von Normans Liebhaber für einen neuen Partner, dargestellt in *And the Little One Said*, zeugt davon. Die letzte Arbeit die sich mit dem Bruch beschäftigt, heißt *Die, Monster, Die* und veranschaulicht offen den Schmerz der

Zurückweisung, gleichzeitig aber auch Zeichen der Wiederherstellung. Das kahlgeschorenen Haupt verkörpert Normans Reaktion auf Ablehnung und Depression. Er veräußert seine eigenen Gefühle von Häßlichkeit durch das Rasieren von Kopf und Augenbrauen.

"Wenn ich mich häßlich *fühle*, kann ich auch gleich schon häßlich *aussehen*." Das Bild zeigt aber gleichzeitig Normans prinzipielle Einstellung: nämlich die Möglichkeit durch Zeichnen und Malen einige der kompliziertesten und wichtigsten Aspekte des Lebens zu verarbeiten – ob schmerzhafter oder erfreulicher Natur. Als Norman in der Nacht, als sein Partner ihn zum ersten mal verließ, *And the Little One Said* zu Papier brachte, lieferte ihm das gleichzeitig die nötige Stütze um mit dem Problem fertig zu werden.

Normans Arbeit bezieht sich weder außschließlich auf Homosexualität, noch ist sie allein für Gleichgesinnte bestimmt. Es geht um *sein* Leben. Als schwuler Künstler bleibt das unausweichlich Hauptthema seiner Arbeit, und in ihr kann man die ehrliche Darstellung einer schmerzhaften Zeit besonders deutlich sehen.

Norman

Norman's sequence of pictures looks at first glance a piece of pure and undisguised autobiography set down just as it happened. In reality the series represents a conscious construction where the significance of events has priority over sequence. The meaning of each stage is only understood from after the event. For example, the first image acts as both introduction and recapitulation to the whole series. In sitting in front of a mirror plucking his eyebrows before going out for an evening he confronts his own image – his personality. This faces him with the most basic of questions: Who is he? What is he doing? It raises his doubts about everything, and in particular whether his relationship with his lover will hold together. The rest of the series is addressed to the answering of these questions.

The narrative sequence contains an internal logic and charts the deterioration of Norman's relationship with his lover. The pictures illustrate themes from gay life almost as a perverse illustration or rejoinder to Chris Corr's propaganda pieces. If *The Mirror* exemplifies personal insecurity, *Lisa Likes a Drink* takes the action on to a nightclub where Norman and his lover are bored with each other as much as with the surroundings.

Boredom in turn develops into violent argument and hostility in *The Broken Door*. This paves the way for the end of the relationship, through the gradual shift in sexual interest of Norman's lover to a new partner, as seen in *And the Little One Said*. The last piece dealing with the breakdown, *Die, Monster, Die*, illustrates at once the pain of rejection but also the grounds for recovery. The shaven head represents Norman's response to rejection and depression. By shaving his head and eyebrows he externalises his own feelings of ugliness – 'If I feel ugly, I might as well look ugly'. But this picture also illustrates Norman's principal thesis: that through drawing and painting one can work out in non-verbal form some of the most perplexing and important aspects of life – both painful and joyous. Putting *And the Little One Said* onto paper the night his lover first left provided Norman with the means of coming to terms with the event.

Norman's work is not constructed in terms of gay life, nor is it for gay people alone. It is about *his* life. As a gay artist this inevitably remains a central issue in his work, and in it we see particularly clearly the honest working out of a painful time.

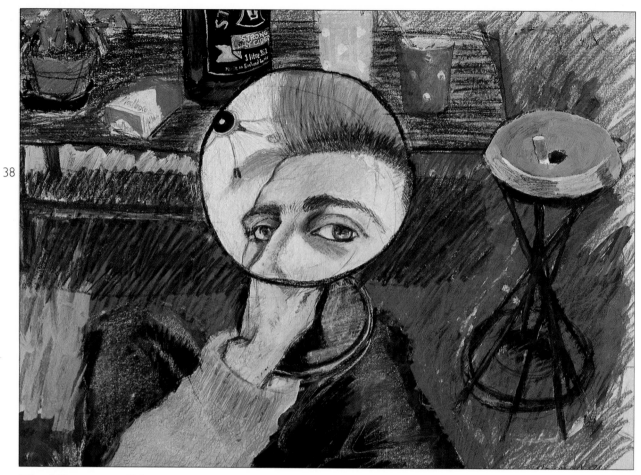

The Mirror 1984

42 x 58 cms

Acrylic

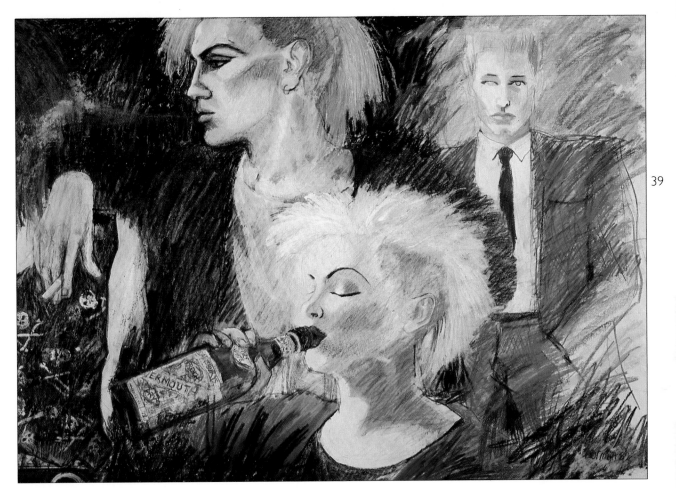

Lisa Likes a Drink 1984

42 x 58 cms

Acrylic

And the Little One Said 1984

63 x 91 cms

Acrylic

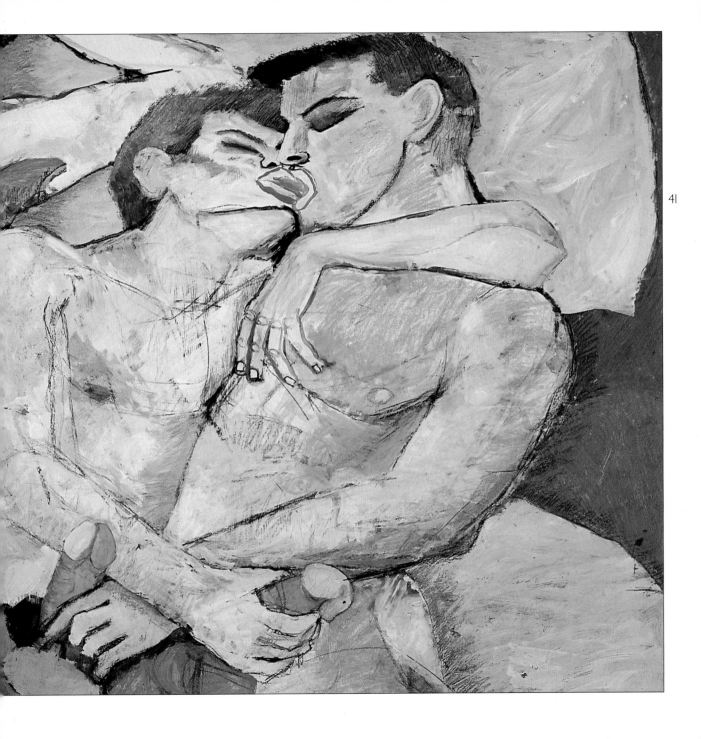

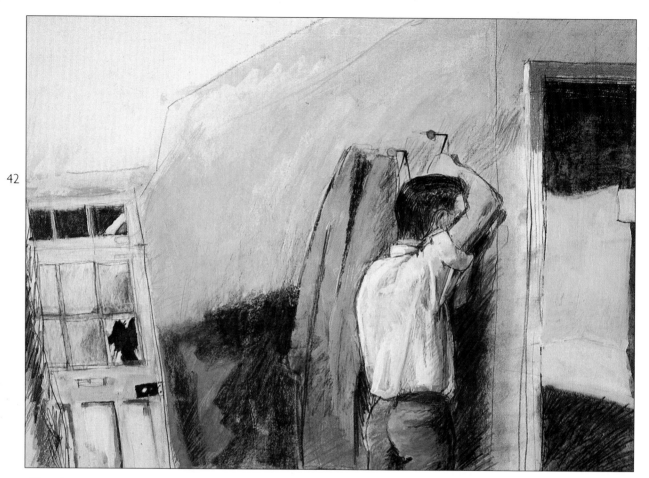

The Broken Door 1984

42 x 58 cms

Acrylic

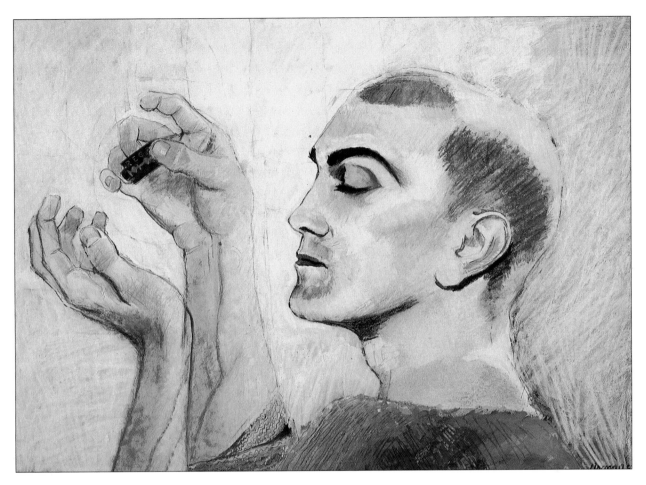

Die, Monster, Die 1984

42 x 58 cms

Acrylic

Il y a quelque chose d'immédiatement inquiétant dans la majorité des oeuvres de Graham Ward – qu'il s'agisse de ses premiers travaux comme *Permafrost* (1982), achevé alors que l'artiste était encore étudiant, ou de plus récents comme *Home Service* et *Boy* (1984 tous les deux). Même les têtes et les portraits peints plus tard partagent le même sentiment de distance. C'est dû en partie au fait que les personnages se tournent si rarement vers le spectateur, préférant se tourner vers eux-mêmes plutôt que vers nous. Par cette forme de présentation, Graham Ward augmente la distance dramatique entre ce qui passe dans le tableau et nous-mêmes. Il y a un sens dans lequel nous trébuchons sur ce qui est déjà en train de se passer – notre présence ne change rien au cours des évènements.

Les sources des images de Graham Ward sont variées, et vont de l'étude de l'historique et de l'horreur des meurtres des Moors (un exemple de la juxtaposition de la vie quotidienne la plus ordinaire à la plus hideuse et la plus macabre) à des références littéraires plus classiques à ses débuts. *Little Tango* en particulier représente cette approche littéraire de la façon la plus directe. Ce tableau se base sur des histoires décousues dans le style de William Burroughs, écrites par un ami de l'artiste. Histoire et tableau traitent du thème de l'enfance homosexuelle, qui à son tour, amène deux autres préoccupations de Graham, celles qu'il appelle les solitaires et les désaxés. C'est la superposition de ces trois éléments qui donne leur force et leur côté malaisé aux images qui nous sont présentées.

Un autre sujet de préoccupation cher à Graham Ward, et qu'on retrouve tout au long de ses tableaux, c'est son intérêt pour les symboles personnels qu'il appelle "icônes". Ce sont les images que nous possédons et chérissons tous et qui nous réconfortent. C'est le cas de la photo dans *Fantasy Friend*. Mais la série de portraits agit de la même façon: ils représentent une condensation des éléments au sein de la composition formelle dans laquelle le décor de fond restreint et les détails rares concentrent notre attention sur la tête. Cette évasion symbolique du détail réaliste souligne l'engagement de Graham Ward envers la phrase de Robert Frost: "Les choses *sont* ce dont elles ont l'air."

Au moyen de ces études d'observation et d'interprétation, Graham Ward dévoile une sensibilité personnelle issue de sa préocuupation avec la croissance du personnage homosexuel. Il ne se réfère pas aux icônes homosexuelles classiques et directes, qui insèrent facilement une image dans une iconographie homosexuelle sans problèmes. Le fardeau de l'oeuvre de Graham Ward, c'est d'insister pour que nous respections l'individualité de chaque existence homosexuelle. Il nous rappelle également que nous vivons dans un plus vaste monde et que les homosexuels peuvent – et souvent le doivent à eux-mêmes – représenter les individus à l'extérieur de la scène homosexuelle.

44

Viele von Graham Wards Arbeiten haben auf den ersten Blick etwas Beunruhigendes. Ob es jetzt um frühe Arbeiten wie z.B. *Permafrost* (1982) – ein Bild das noch zu Collegezeiten entstand, geht, oder um die jüngeren Arbeiten *Home Service* und *Boy* (beide 1984). Sogar die späteren Porträts und Köpfe teilen dieses Gefühl von Distanz. Das ist wohl teilweise auf die Tatsache zurückzuführen, daß die Personen so selten auf den Betrachter Bezug nehmen, vielmehr introvertiert erscheinen, als im Gespräch mit uns. Durch diese Form der Darstellung erhöht Graham Ward die dramatische Distanz zwischen dem, was im Bild geschieht und uns. Das gibt ein Gefühl, als ob wir nur versehentlich Einsicht haben in das, was schon ohne uns begonnen hat – unsere Gegenwart beeinflußt das Geschehen nicht.

Die Quellen zu Graham Wards Themen sind ganz verschieden, angefangen von der Beschäftigung mit Geschichte und Grauen der Moormörder (einem Beispiel des Nebeneinander von ganz normalem Alltag mit gräßlichsten und abscheulichsten Geschehen), bis hin zu ganz gewöhnlichen Literaturanfängen. *Little Tango* zeigt die literarische Annäherung besonders offen. Das Bild basiert auf den unzusammenhängenden Geschichten im Stil von William Burroughs, die ein Freund des Künstlers schrieb. Geschichte und Bild haben eine homosexuelle Kindheit zum Thema. Homosexuelle Kindheit wiederum bezieht sich auf zwei weitere Interessen Grahams, nämlich jene Individuen, die er Einsame und Einzelgänger nennt. Die Vereinigung dieser drei Elemente gibt den Motiven die starken und unbequemen Aussagen mit denen wir konfrontiert werden.

Ein weiteres Anliegen, das sich in allen Bilderserien Graham Wards wiederfinden läßt, ist sein Interesse an persönlichen Symbolen, die er "Ikonen" nennt. Gemeint sind Vorstellungen, die wir alle haben und schätzen, Vorstellungen, die uns Labsal und Trost sind. Das Photo in *Fantasy Friend* bot solch eine "Ikone" schon an. Die Porträtserien haben eine ähnliche Wirkung. Sie zeigen die Verschmelzung verschiedener

Elemente zu einer formalen Komposition, die durch spar-samen Hintergrund und wenig Detail die Aufmerksamkeit auf den Kopf lenkt. Diese Symbolik der Abwendung vom realistischen Detail unterstreicht die Identifizierung mit einem Ausspruch von Robert Frost: "Die Dinge *sind* wie sie scheinen."

Mit diesen Beobachtungsstudien und Interpretationen zeigt Graham Ward eine persönliche "Sensibilität", die aus seiner Auseinandersetzung mit der Entwicklung des homosexuellen Charakters erwächst. Graham Ward bezieht sich nicht auf die Symbol, die man normalerweise sofort mit Schwulen verbindet, nämlich solche Vorstellungen, die schnell mit unproblematischer homosexueller Metaphorik in einen Topf geworfen werden. Die Bürde seiner Arbeit liegt vielmehr darin, daß er darauf beharrt, daß man die Individualität jedes einzelnen Schwulen-Schicksals respektiert. Graham Ward hebt damit hervor, daß wir in einer vielschichtigen Welt leben, in der der Homosexuelle seine Individualität außerhalb der homophilen Gesellschaft leben kann und sich auch eigentlich selber schuldig ist.

45

Graham Ward

There is something immediately disquietening about the majority of Graham Ward's output – whether the subject be early work such as *Permafrost* (1982) completed while the artist was still at college, or the more recent *Home Service* and *Boy* (both 1984). Even the later portraits and heads share the same feeling of distance. This is partly due to the fact that the subjects so seldom engage with the viewer of the picture, preferring to look inside themselves rather than out at us. By this form of presentation Graham Ward increases the dramatic distance between what is going on in the picture and ourselves. There is a sense in which we merely stumble across what is already going on – we do not by our presence affect events.

The sources of Graham Ward's images are diverse, from a study of the history and horror of the Moors murders (an example of the juxtaposition of the most ordinary everyday life with the most hideous and macabre) to more straightfor-ward literary beginnings. *Little Tango* in particular represents the literary approach at its most direct. The picture is based on the disjointed stories in the style of William Burroughs produced by a friend of the artist. The story and picture take up the theme of a gay childhood. Gay childhood in turn relates to two other concerns of Graham's, those individuals he calls loners and misfits. It is the bringing together of these three elements that provides the strength and uncomfortableness of the images with which we are presented.

Another concern of Graham Ward's that runs throughout the series of pictures is his interest in personal symbols that he calls 'ikons'. These are images that we all have and cherish and which provide us with comfort. The photograph in *Fantasy Friend* has already been offered as one such ikon. But the series of portraits also works in this way: they represent a condensation of elements into the formal composition where economy of background and sparsity of detail concentrate our attention on the head. This symbolic turning away from realist detail emphasises Graham Ward's commitment to Robert Frost's dictum 'Things *are* what they seem'.

By these studies of observation and interpretation Graham Ward provides a personal 'sensibility' which develops from his concern with the growth in the gay character. He does not refer to the usual direct gay ikons which easily slot an image into an unproblematic gay iconography. The burden of Graham Ward's work is to insist that we respect the individuality of each gay life. He also reminds us that we live in a wider world and that gay men can and often owe it to themselves to represent individuals outside the gay areas.

Permafrost 1982

61 x 30 cms

Graphite

46

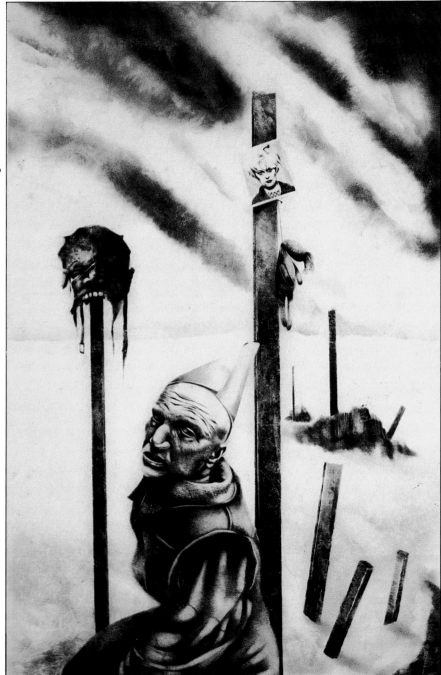

Boy 1984

15 × 15 cms

Graphite, white powder paint

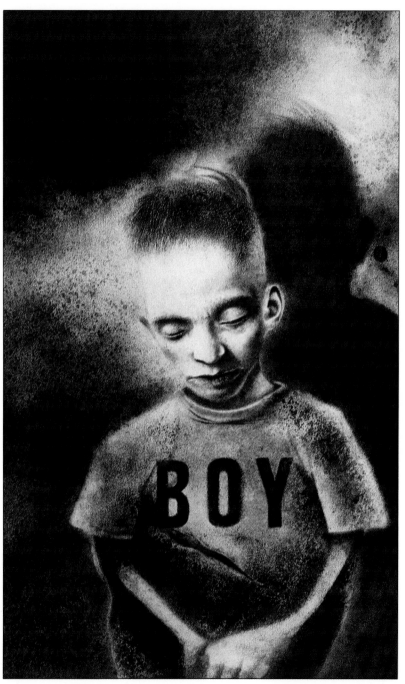

48

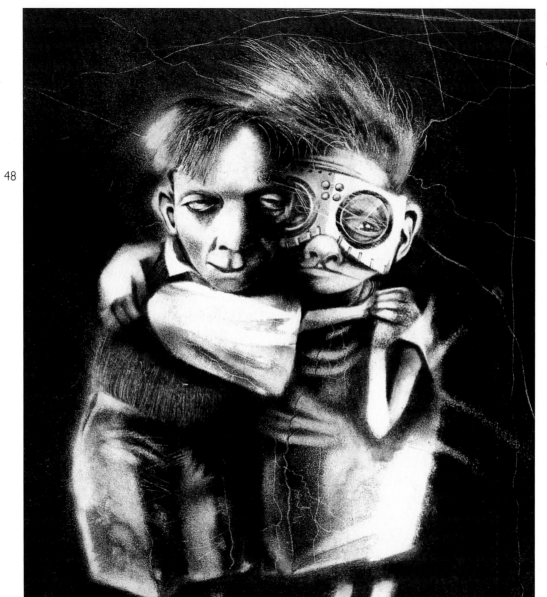

Little Tango 198

30 x 51 cms

Graphite, watercolour,
white powder paint

Fantasy Friend 1982

23 × 50 cms

Graphite, white powder paint

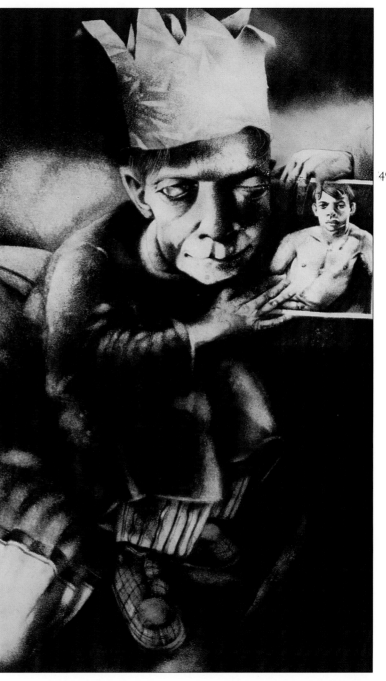

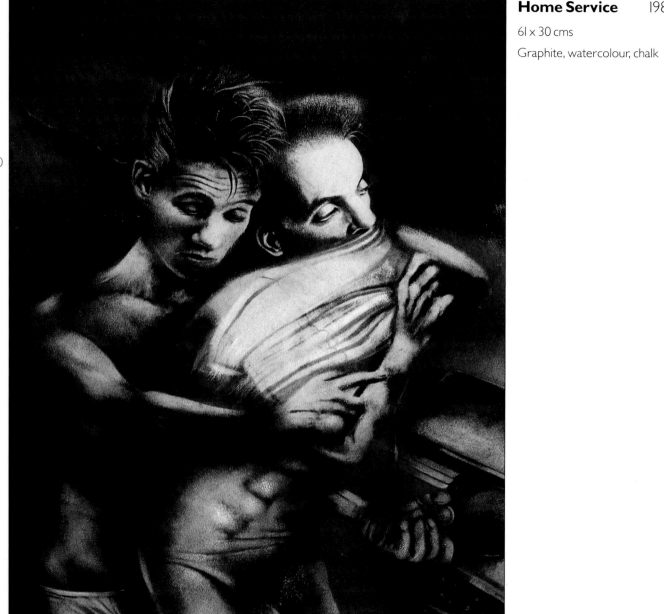

Home Service 1984

61 x 30 cms

Graphite, watercolour, chalk

Christopher Brown

1984

20 x 25 cms

Pencil, watercolour,
gouache, letraset

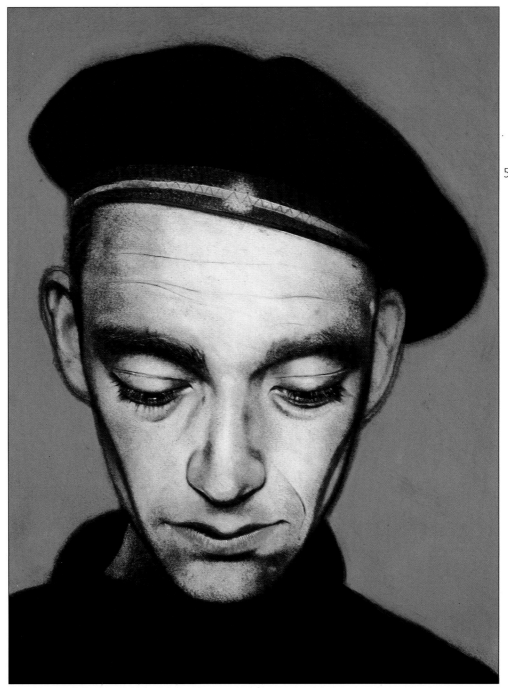

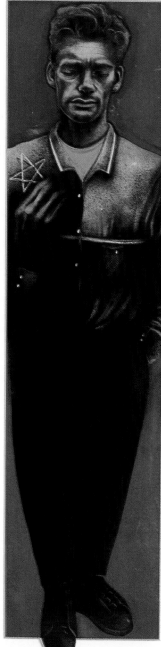

52

Christopher Brown 1984

61 x 15 cms

Pencil, watercolour, gouache, letraset

Melissa Raphael 1984

61 x 15 cms

Pencil, watercolour, gouache, letraset

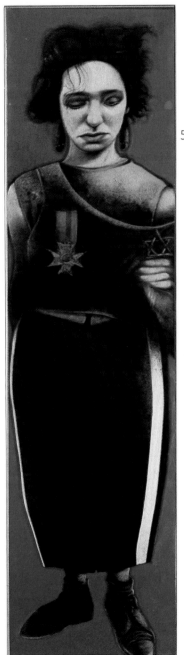

53

La collection des oeuvres de Richard Royle fournit une intéressante conclusion au groupe. D'un côté, ses préoccupations sont les mêmes que celles des autres – explorer et faire la preuve de l'étendue et des limites de l'expérience des homosexuels – mais d'un autre côté, il utilise différents supports techniques et expressifs, rapprochant l'art et la vie quotidienne et intensifiant la tension entre les deux. Le fait qu'il travaille presque exclusivement avec des textiles veut dire que ses oeuvres ont un impact différent et un sens différent des oeuvres bidimensionnelles sur papier. Les textiles lui permettent de jouer avec les images, en surimprimant, en juxtaposant et en percevant un sujet à travers un autre. Parce que les textes ont un statut limité dans le domaine de l'art, l'artiste est moins restreint qu'avec d'autres supports. Les textiles s'utilisent aussi dans des oeuvres non-artistiques. Richard Royle emploie à fond cette possibilité et transforme les images imprimées en bannières mais aussi en couvre-lits et même en chemises.

Les couvre-lits et les bannières sont un emblème et ont la même structure de collage. Ils rapprochent des références séparées qui, en s'unissant, donnent un sens personnel très fort à ces oeuvres, tout en demeurant ouverts à notre propre interprétation. Il y a une ambiguïté spéciale dans le couvre-lit à double face qui répète une imagerie érotique et dérangeante dans le plus intime et le plus personnel des contextes: les draps de lits.

Les images tirées de la pornographie homosexuelle sont à la fois surprenantes et prosaïques quand on les retrouve sur une chemise. Pour Richard Royle, les chemises, tout comme d'autres textiles, donnent des symboles d'identité personnelle et renforcent sa théorie qui est que non seulement ce que vous pensez, mais ce que vous portez, détient la clé de ce que vous êtes.

54

Richard Royles Arbeiten geben der Gruppe eine zusätzliche Anregung. Obwohl sein Interessenbereich dem der Anderen ähnlich sieht, nähmlich die Erforschung und Darstellung von Spielraum und Grenzen in den Erfahrungen homosexueller Männer, unterscheidet er sich durch die Benutzung anderer technischer Ausdrucksmittel, indem er Kunst und Alltag näher bringt, die Spannung zwischen beiden zu einem neuen Grad erhöht, haben seine Kunstwerke eine andere Wirkung, eine andere Bedeutung im Vergleich zu zweidimensionalen Arbeiten auf Papier. Der Gebrauch von Textilien erlaubt ihm seine Vorstellungen auszuprobieren, Materialien zu überdrucken und nebeneinander zu setzen, ein Detail durch ein anderes sichtbar zu machen. Textil hat ansich eine geringe Stellung in der Kunsthierarchie, das macht den Künstler unbefangener als in anderen Medien. Textilarbeiten kann man auch in non-artistischer Umgebung gebrauchen. Richard Royle nutzt diese Möglichkeit voll aus und macht nicht nur Banner aus seinen Stoffdrucken, sondern auch Steppdecken und Hemden.

Steppdecken und Banner fungieren beide als Embleme und sind in der Strukturierung der Collagen gleich. Die einzelnen Elemente haben vereint eine aussagekräftige Wirkung von individuellem Ausdruck und lassen dabei dennoch unseren eigenen Interpretationen Raum. Außerdem hat der doppelseitige Quilt eine zusätzliche Ambivalenz mit seinen Mustern erotischer und anstößiger Darstellungen in dem intimsten und persönlichsten kontext – Bettwäsche.

Darstellungen homosexueller Pornographie sind sowohl schockierend als auch den Tatsachen entsprechend, ganz besonders wenn sie auf Hemden zu sehen sind. Richard Royle sieht Hemden, sowohl als andere Kleidung, als ein Symbol der eigenen Identität. Das verstärkt seine Behauptung, daß nicht nur das, was wir sagen, sondern auch das, was wir tragen, Schlüssel zu unserem Selbst ist.

Richard Royle

Richard Royle's collection of pieces provides an exciting conclusion to the group. On the one hand, his concerns are the same as the others – to explore and to demonstrate the range and limitation of experience for gay men – but on the other hand, he employs different technical and expressive media, bringing art and everyday life closer and thus building up the tension between the two to a new pitch. The fact that he works almost exclusively in textiles means that the artworks have a different impact and a different meaning from two-dimensional work on paper. Using textiles permits him to play around with images, overprinting and juxtaposing, seeing one item through another. Because textiles have a lowly place in the hierarchy of art, the artist is less circumscribed than in other media. Textiles can also be employed in non-art settings. Richard Royle makes full use of this possibility and makes the printed images not only into banners but also bed quilts and even shirts.

Both quilts and banners act as emblems and have the same collage construction. They bring together separate references which become powerfully united into personal meaning that still remains open to our interpretation. There is a particular ambiguity in the double-sided quilt that repeats erotic and uncomfortable imagery in the most intimate and personal of contexts – bedclothes.

Images from gay pornography are both startling and yet matter-of-fact when seen on a shirt. For Richard Royle, shirts, in common with other textiles, provide symbols of personal identity and reinforce his contention that not only what you think but what you wear is the key to what you are.

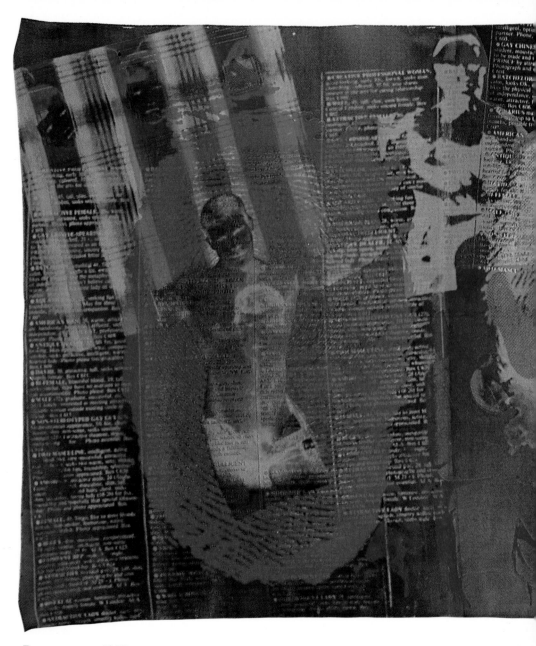

Banner 1983

198 x 122 cms

Textile print

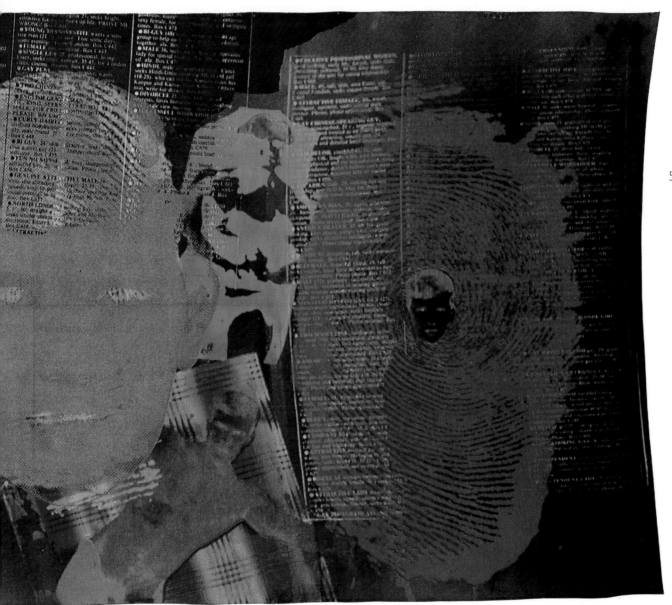

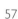

58

The Pornographer 1984

183 x 183 cms

Textile print

Lonely Hearts 1982

81 x 165 cms

Textile print

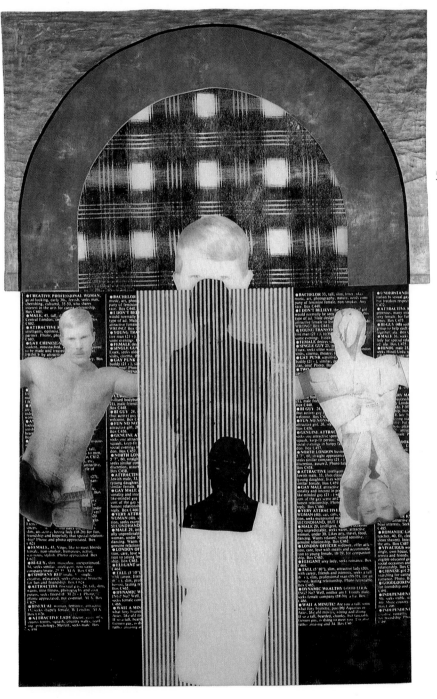

60

Bed Quilt
(reverse side)
1983
183 × 152 cms
Textile print

Bed Quilt

1983

183 × 152 cms

Textile print

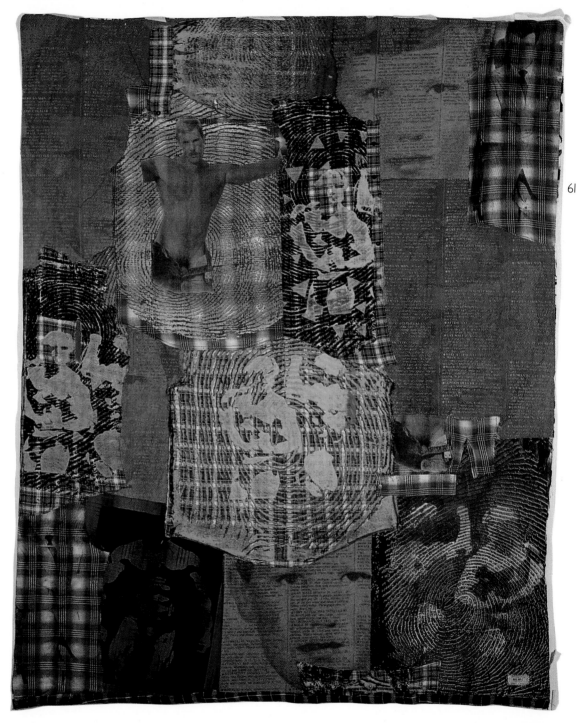

Richard Royle

Index

◇ *Fine Art Books from GMP*

Philip Core

PAINTINGS: 1975-1985

Introduced by George Melly
40 colour plates

Mario Dubsky

TOM PILGRIM'S PROGRESS AMONG THE CONSEQUENCES OF CHRISTIANITY

Introduced by Edward Lucie-Smith
64 b/w plates

Juan Davila

HYSTERICAL TEARS

Edited by Paul Taylor
35 colour plates

David Hutter

NUDES AND FLOWERS

Introduced by Edward Lucie-Smith
40 colour plates

Michael Leonard

PAINTINGS

Foreword by Lincoln Kirstein
The artist in conversation with
Edward Lucie-Smith

40 colour plates

Michael Leonard

CHANGING

Introduced by Edward Lucie-Smith
50 b/w plates

Cornelius McCarthy

INTERIORS

Introduced by Emmanuel Cooper
40 colour plates

Douglas Simonson

HAWAII

40 colour plates

◇ *Art Photography*

George Dureau

NEW ORLEANS

Introduced by Edward Lucie-Smith
50 duotone plates

Wilhelm von Gloeden

TAORMINA

Introduced by Emmanuel Cooper
20 b/w plates

◇ Full catalogue available on request from
GMP Publishers Ltd, P O Box 247, London NI5 6RW